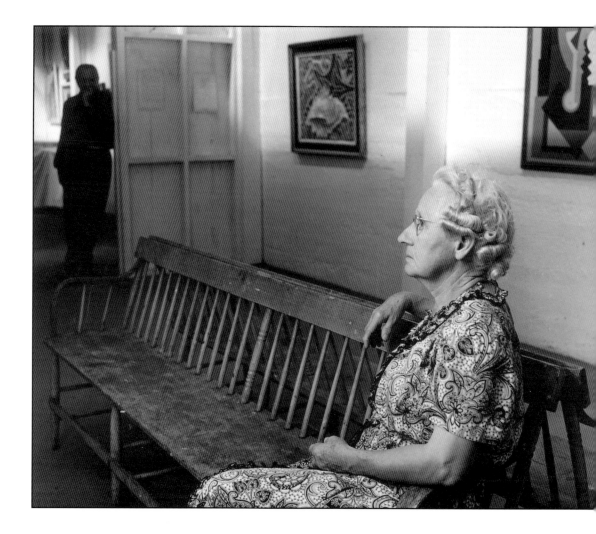

Blanche Lazzell: THE HOFMANN DRAWINGS

Robert Bridges and Kristina Olson

This catalog was published on the occasion of the exhibition, *Blanche Lazzell: The Hofmann Drawings*, curated by **Robert Bridges** and **Kristina Olson,** at the Mesaros Galleries, West Virginia University, Morgantown, West Virginia, March 4– April 3, 2004.

The design and publication of this catalog was made possible through the generosity of the **Colonel Eugene E. Myers Foundation.** The study of the work of Blanche Lazzell was assisted by support from a **West Virginia Humanities Council Fellowship**.

The authors would like to acknowledge colleagues and individuals who were instrumental to this project including **J. Bernard Schultz, Sergio Soave, Janet E. Snyder, Jennifer E. Friar, Harvey D. Peyton, Martin and Harriett Diamond, Christie Mayer Lefkowith and Edwin F. Lefkowith, Lucie Mellert, James C. and Janet G. Reed,** and the members of the **Lazzell** family. We honor the late **John Clarkson** for his ground-breaking research and curatorial work on Blanche Lazzell.

This catalog anticipates the publication of the book **Blanche Lazzell: The Life and Work of an American Modernist,** edited by **Robert Bridges, Kristina Olson,** and **Janet Snyder, West Virginia University Press**, www.wvupress.com or 1-866-WVU-PRESS, available summer 2004.

Catalog designed by **Lisa Bridges Design**

ISBN: 0-9752787-0-3

Cover image: **Blanche Lazzell,** untitled drawing with Hofmann annotations, marked "summer 1937" (1937), charcoal on paper, 25 x 19 inches (63.5 x 48.3 cm), West Virginia University Art Collection, 1995.002.038

Photograph opposite title page: **Blanche Lazzell** with **Hans Hofmann** in background at Gallery 200, Provincetown (summer 1949), photo by **Bill Witt**, courtesy West Virginia and Regional History Collection

CONTENTS

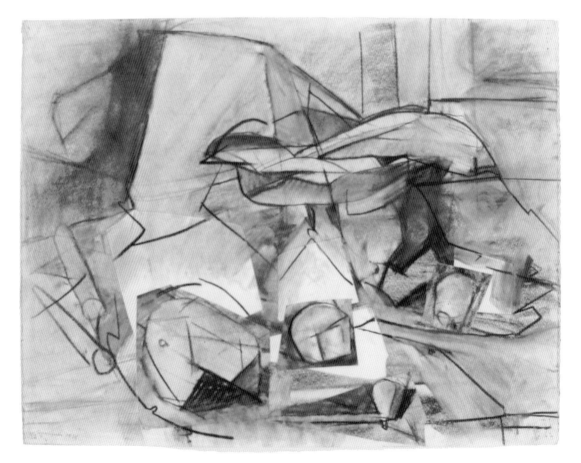

Figure 1–**Blanche Lazzell,** untitled drawing marked "summer 1938" (1938), charcoal on paper,
19 x 25 inches (48.3 x 63.5cm), West Virginia University Art Collection, 1995.002.033

INTRODUCTION

ROBERT BRIDGES

In the summer of 1937, Blanche Lazzell (1878–1956), at age fifty-nine, joined German-born modernist Hans Hofmann's Provincetown drawing class. By August of that year, Hofmann had visited Lazzell's nearby waterfront studio and the following week he returned with his class.[1] Lazzell's studio walls at that time were lined with non-objective cubist paintings and abstract color woodblock prints. No doubt Hofmann, two years younger than Lazzell, felt an artistic connection to this unassuming artist. Both artists' work was strongly informed by cubism and fauvism.[2] Always eager to pursue instruction from artists she admired, Lazzell participated in Hofmann's classes in the summers of 1937 and 1938 and attended his New York school in the spring of 1938. Beginning with her earliest art classes and continuing for the next fifty years, Lazzell sought out artists and teachers for advanced study.

Blanche Lazzell's artistic education began at West Virginia University where she received a degree in 1905. In 1907–08 she studied with William Merrit Chase at the Art Students League, and in 1912, she enrolled at the Académie Julian and the Académie Moderne in Paris. She traveled to the art colony of Provincetown, Massachusetts in the summer of 1915, to study under Charles Hawthorne. It was in Provincetown in the teens where her art became more and more informed by modernism. Artists Marsden Hartley, Charles Demuth, and William Zorach were working there as well as Oliver Chaffee, who was responsible for instructing Lazzell in the white-line woodblock print for which she is so well known.[3] In 1923, at the age of forty-five, Lazzell returned to Paris and devoted herself to the study of cubism, taking classes with Fernand Legér, André Lhote, and Albert Gleizes. This trip marked the end of Lazzell's quest to study with important artists. She would not be interested in another artist-teacher until Hofmann arrived in Provincetown in 1935.

This exhibition and catalog represent evidence of a mature artist at a turning point in her career. In the early 1930s Lazzell was creating some highly-regarded abstracted still-life prints. However, the American art scene of the thirties was more conservative and, due to her heavy involvement with the Federal Art Project, her work became more representational. Due to high demand by the Works Project Administration officials for Lazzell's white-line woodblock prints, she spent much of her time from 1934–1939 creating art for the Federal Art Projects.[4] Her work was by no means as unadventurous as the "conservatives" Lazzell railed against in the Provincetown Art Association annual members' exhibition, but her work of the mid-thirties was less abstract. The imagery was mostly popular landscapes from her native home in West Virginia and around her studio home in Provincetown. Her involvement with Hofmann and the principles of composition he advocated helped Lazzell return to abstraction. In a series of letters to Grace Frame to encourage the younger West Virginia artist to come to Provincetown to study with Hofmann, Lazzell writes about his influence.[5] In one, she reflects on a flower still-life arrangement she was contemplating:

> I have been studying these fluffy petunias and find the very universe concealed within their delicate petals—all that tension movement and counter movement and all that Hofmann talks about. And how powerless one feels in the face of all that—yes in the calm beautiful face of a petunia.[6]

The Provincetown art community was a fairly close-knit group and Lazzell became friends with Hofmann and his wife, Miz. She would later attend many of his exhibitions in New York. In 1943, Lazzell wrote enthusiastically about having dinner with the Hofmanns at his studio on 8th street. Lazzell was impressed with the large white studio and big paintings, some of which were being created "even flat on the floor."[7]

The drawings in this exhibition represent only a small portion of the Lazzell holdings at West Virginia University. This collection spans her career and includes paintings, prints, decorative items, and drawings that come largely from the artist's bequest to the University. Lazzell's relatives James and Janet Reed were responsible for bringing the portfolio of sixty-seven drawings from Hofmann's classes into the collection. Other donors, including relative Frances Sellers, have helped make the West Virginia University Art Collection the largest public holding of Blanche Lazzell's work.

Robert Bridges is curator of the West Virginia University Art Collection
and the Mesaros Galleries

NOTES

[Abbreviation: "ALS" indicates an autographed letter, signed.]

[1] Blanche Lazzell, Provincetown, MA to Grace Martin Taylor, Charleston, WV, 9 January 1938, ALS, courtesy of Lucie Mellert.

[2] A discussion of Hofmann's connection to European modernism can be found in Cynthia Goodman, *Hans Hofmann* (New York: Abbeville Press, 1986). For a full discussion of Lazzell's influences see the forthcoming book: *Blanche Lazzell: The Life and Work of an American Modernist*, edited by Robert Bridges, Kristina Olson, and Janet Snyder (Morgantown, WV: West Virginia University Press, 2004).

[3] Lazzell's prints were the subject of Barbara Stern Shapiro's recent exhibition, *From Paris to Provincetown: Blanche Lazzell and the Color Woodcut* (Boston: Museum of Fine Arts, 2002).

[4] In several letters to Grace Martin Frame from this period Lazzell complained about the amount of time she was spending getting prints to the WPA. In one she wrote, "I did some prints and paintings for the WPA- but nothing, I mean not much painting outside of WPA work." Blanche Lazzell, Provincetown, MA to Grace Martin Frame, Charleston, WV, 1 July, 1937, ALS, courtesy of Lucie Mellert.

[5] Grace Martin Frame (1903–1995), later Grace Martin Frame Taylor, became a noted artist in her own right.

[6] Blanche Lazzell, Provincetown, MA to Grace Martin Frame, Charleston, WV, 29 October, 1940, ALS, courtesy of Lucie Mellert.

[7] Blanche Lazzell, St. Augustine, FL to Grace Martin Frame, Charleston, WV, 20 December, 1943, ALS, courtesy of Lucie Mellert.

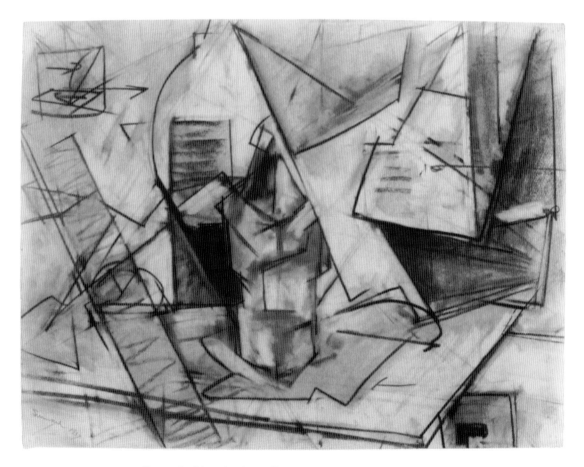

Figure 2–**Blanche Lazzell**, untitled drawing marked "summer 1937" (1937) charcoal on paper,
19 x 25 inches (48.3 x 63.5cm), West Virginia University Art Collection, 1995.002.031

HANS HOFMANN'S
IMPACT ON THE LATE WORK OF BLANCHE LAZZELL

BY KRISTINA OLSON

Throughout her life, Blanche Lazzell made artistic breakthroughs at times when she was in the stimulating company of advanced artists. This happened many times during her long career, including on her two trips to Europe and in her early years in Provincetown, Massachusetts, beginning in 1915. Probably the most significant association of her late career was the one that began in the late 1930s when she attended classes with the important abstract painter, Hans Hofmann (1880–1966).

Hofmann helped reinvigorate Lazzell's late abstract work and connected her to the abstract expressionist generation of American artists. Hofmann's role as a teacher of modernism to American artists is legendary. He conducted a summer school in Provincetown, where Lazzell had long lived, from 1935 until 1958.[1] The selected Lazzell drawings from the West Virginia University Art Collection exhibited here offer a concentrated look at Hofmann's lessons. An examination of a few of these drawings, in light of Hofmann's teaching practice, will uncover some of his general principles and their impact on Lazzell. A final consideration of a few of Lazzell's late works will reveal the lasting import of Hofmann's ideas. It is clear that Hofmann helped Lazzell recommit to abstraction late in life. Most certainly, Hofmann's friendship during Lazzell's last twenty years was critical for introducing her work to younger abstract artists.

Long before she met Hans Hofmann, Blanche Lazzell was experienced with the laws of cubist abstraction. In a draft of an essay on modern art dated 1916 (probably intended as a speech for the Morgantown, West Virginia, chapter of the Daughters of the American Revolution), Lazzell detailed her understanding of cubism:

Cezanne suggested Cubism. Picasso with others carried it out, and provided compositions of cubes and cones which added still more strength to the organizations of form and mass. Another form of the abstract was yet to appear, that is the organization of flat planes of color, with an interplay of space, instead of perspective. Picasso, Mr. Albert Gleizes and Braque are leaders in this style of abstract.[2]

Lazzell had probably been introduced to the work of Albert Gleizes (1881–1953) on her first trip to Europe in 1912–13, and she made a point of studying with him in Paris at length on her second trip, beginning in 1924.[3]

This embrace of Gleizes's version of synthetic cubism caused a profound shift in Lazzell's work that is evident in the ambitious series of abstract paintings she produced beginning in 1924. Each piece in the series of cubist paintings presents either a square or, more commonly, vertically-oriented, non-objective composition, see *Painting, No.1,* 1925 (figure 3). There is a complicated over-

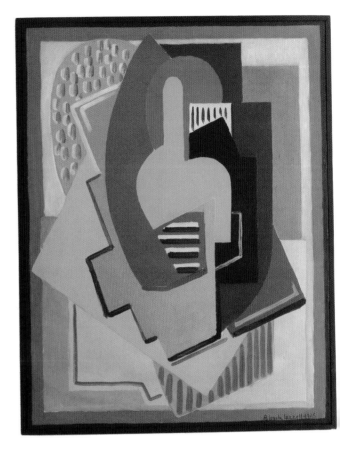

FIGURE 3—**Blanche Lazzell**
Painting No. 1 (1925), oil on canvas
36 x 28 inches (91.5 x 71.1 cm)
West Virginia University Art Collection, 1995.025.008
acquired through James C. and Janet G. Reed

lapping of irregular planes in the composition that appear to stack up from the outer-edges of the canvas (or paper) to the center. The planes are left utterly uninflected in some versions and strongly patterned with stripes, dots and checks in others. The unmixed colors are intense and range from red, to lemon yellow, to violet, aqua, and eggplant. Movement is suggested through planes set at diagonals or through curved edges.

Though the composition is in no way illusionistic, certain elements hint at a still life (a favorite subject in Lazzell's oeuvre). There is the suggestion of a central bottle-form in some, such as *Painting No.1*, a bowl of fruit in another, and perhaps a stringed instrument in several. Certainly,

this composition has precedent in avant-garde still lifes of the teens and twenties by artists ranging from Pablo Picasso to Liubov Popova.

Of course, for the composition, Lazzell is immediately indebted to Albert Gleizes. The artist/teacher made diagrams of such compositions to illustrate his application of cubist principles in his treatise *La Peinture et ses lois* of 1924.[4] Lazzell had been preparing similar studies under Gleizes's direction and completed the first several painted versions of the composition while still in Paris.

Lazzell summarized these paintings when she discussed them at length with a reporter for the *Boston Sunday Post* on 7 July 1929:

> This is a series of different planes, one placed against another to bring about a certain interplay. As you see, it is a matter of space relations, not of perspective. . . . The color scheme I try to keep very simple. In this, for example, I used vermilion, yellow and blue-green, and I do very little mixing of colors; it is too hard to make the planes stay back in their places. I try to make these planes balance as well as possible—that gives the harmony of line or rhythm that is the motif of decoration.[5]

The compositional structure of these cubist paintings provided a foundation for Lazzell's later work, even when she returned to more recognizable subject matter. Lazzell took this affinity for working on the surface with interlocking planes (in her more abstract work), or with brushstrokes (in her more expressionistic work) of high-keyed, unmodulated color to all of her mature work. These paintings demonstrate her modernist understanding of how to imply spatial relationships and movement through overlapping, diagonals, and color without relying on traditional illusionistic tricks. It was to this well-established foundation in cubist abstraction that Lazzell added Hofmann's insights.

Hans Hofmann's teaching in Europe and America spanned more than four decades. After operating a school in Munich in his native Germany since 1915, Hofmann immigrated to America in 1930, initially teaching in California. In 1933, he moved to New York to teach at the Arts Student League prior to opening his own school there.[6] Hofmann's impact as a teacher was probably strongest in this period from 1933 to 1958 when he operated his school in New York with the summer program in Provincetown.

Art historian Irving Sandler has noted that, "If a teacher's stature is measured by the number of his students who achieve national and international renown in their own right, then that of Hofmann is without equal."[7] In the late 1930s, about half of the members of the ascendant abstract expressionist movement had attended Hofmann's classes and, in the 1950s, most of those artists who comprised the second-generation New York School had studied with him. The list of notable Hofmann students includes: Nell Blaine, Peter Busa, Fritz Bultman, Ray Eames, Helen Frankenthaler, Jane Freilicher, Robert Goodnough, Red Grooms, Carl Holty, Wolf Kahn, Allan Kaprow, Lee Krasner, Marisol, Joan Mitchell, Louise Nevelson, Robert De Niro, Larry Rivers, and Richard Stankiewicz.[8]

Hofmann's appeal as a teacher went beyond the considerable force of his personality and his direct connection to the masters of European modernism. It most-importantly involved his ability to provide the techniques and rationale to make a modern picture. Critic Harold Rosenberg summarized Hofmann's pedagogical approach, writing, "The basic axiom of Hofmann's teaching, as well as of his painting, was that every formal and technical concept must have its equivalent in feeling or it will result in mere decoration."[9] (See Hofmann's *Still Life,* from 1943, plate 9.)

Hofmann's main formal lesson to students was to activate a composition through an interplay of space. He articulated this lesson through his well-known emphasis on the push-and-pull of pictorial space:

> Out of a feeling of depth, a sense of movement develops itself. Depth in a pictorial plastic sense is not created by the arrangement of objects one behind the other, toward a vanishing point, in the sense of Renaissance perspective, but on the contrary by the creation of forces in the sense of push and pull.[10]

The goal in his classes was to focus on the mechanics of evoking the third dimension in accord with the two-dimensional nature of the picture surface. All subject matter was reduced to a series of planes that abstractly expressed nature's volumes. As Sandler notes:

> The crucial action was to structure these planes into "complexes," every element of which was to be reinvested with a sense of space—depth or volume—without sacrificing physical flatness. To achieve this simultaneous two- and three-dimensionality, Hofmann devised the technique of "push and pull''—an improvisational orchestration of areas of color, or as he liked to put it, an answering of force with counterforce.[11]

In class, drawing was used as the primary means to come to terms with these principles.

In 1937 and 1938, when Lazzell took classes, the Hofmann summer school was located in a barn-like structure on Miller Hill Road in Provincetown. The daily schedule for the course followed that of the New York school. There was a morning and an afternoon session and one could enroll in one or both for as little as a week or for up to twelve, the full run of the course. In the mornings, students drew from a live model while the afternoons were devoted to working from still-life arrangements. Hofmann was usually in class two days a week including Fridays when formal critiques were held in the garden.[12]

The figure studies and still lifes that Lazzell drew with Hofmann show her gaining a command of his principles. Such drawings were not considered finished works, but rather working studies in which to come to terms with the modern pictorial principles that Hofmann espoused. The teacher's hand is evident throughout these drawings in the arrows, schematic notations, plus and minus symbols, and even in the torn sheets (see Lazzell's untitled drawing from 1938, plate 5.) Hofmann would often rip a drawing to demonstrate another way to activate a rigid composition. He would shift the torn paper to the right or left to increase the tension in the drawing. Nell Blaine has explained, "The drawing [was] not to be a thing in itself, but a process of study, so we [were] not to try to make pictures, but [were] having experiences."[13]

Many scholars and former students have deciphered some of these common Hofmann markings on the drawings.[14] Lazzell's own class notes record these same insights. For example, a charcoal drawing of a seated nude from 1937 bears Hofmann's notes about which planes to bring out (+) and which to allow to recede (-) (plate 2). Lazzell's efforts to animate this play of space can be traced through her drawings of this same seated model (see plates 1 through 4).

In her notes from her first lesson with Hofmann, Lazzell quotes him as saying, "Movement of volumes against each other give spatial tensions."[15] In a later lesson, she copies a diagram made by Hofmann and notes, "Planes move around the volume independent of the movement of the volume. For example in a head the fundamental shape may be either a cube or a sphere but around these in many directions move planes which may express the character.— They are forces coming from inside which create the outside."[16]

Hofmann's emphasis on movement must have struck a chord with Lazzell who had heard Gleizes espouse a similar desire to animate cubist planes more than ten years earlier. The

systems these teachers came up with to reach this goal are quite different. Where Gleizes sought a dynamic rhythm of repeated planes on a flat surface, Hofmann aimed for an interaction between planes at differing layers of pictorial space.

This lesson in movement by Hofmann can be seen in a schematized diagram on a Lazzell still life from 1937 (see figure 2). Hofmann's unusual still-life arrangements and his insistence on working from the same arrangement for long periods are famous. One former student, who studied with Hofmann at his second Provincetown studio at the back of a house he and his wife Miz had on Commercial Street, recounts that, "Hofmann carefully arranged several still-lifes, created at the start of each summer term and purposely left untouched all summer long. The still-lifes were different from any others I had seen, and the three-month exposure for continuous study was also unusual but very effective."[17]

Hofmann's inset diagram on the 1937 Lazzell still life uses arrows to suggest how to get a greater sense of movement into the composition. He has indicated that she should slide the surface of the table at a slight angle to the left, while the still life objects should project more and move to the right. Additionally, he has suggested through a curved line that Lazzell reorient the vertical tilt of the volumes of the still life objects to the right. Undoubtedly, Hofmann's goal was to get more tension into the drawing. In a page from her class notes, Lazzell copied a Hofmann sketch noting, "Diagram showing tension to the left increased as the point is moved to the right."[18] This is exactly what he's indicating Lazzell should do in her still life drawing.

Ultimately, these specific exercises with Hofmann were eagerly absorbed by Lazzell because they resonated with her own artistic goals. It will be easy to see how she made use of his lessons in her late work.

In addition to Hofmann, many of the key figures in the abstract expressionist movement spent summers in Provincetown. Between 1938 and 1954 such artists as Arshile Gorky, Adolph Gottlieb, Jackson Pollock, Lee Krasner, William Baziotes, and Mark Rothko all spent time at the art colony.[19] Since she was always interested in being part of an artistic community and in coming to terms with the latest developments in art, it is not surprising that Lazzell connected with this younger group through Hofmann. It is appropriate that these artists would recognize Lazzell for

her role as a pioneer abstract artist just as their careers were taking off. They gave her this honor during the important forum held in Provincetown during the summer of 1949.

"Forum 49" was a summer-long series of lectures, discussions, and exhibitions that fore-grounded the new developments in contemporary art. It was put together by the poet and critic Weldon Kees, artist Fritz Bultman, and poet Cecil Hemley. Critic Clement Greenberg pronounced that, "What you have scheduled, looks like the most exciting thing in art ever to be run outside New York in the summer—or in the winter too."[20]

Hofmann and artist Karl Knaths selected the work of fifty artists, including the major abstract expressionists, for an exhibition held at Gallery 200 that summer as part of the Forum. Lazzell was included with three other pioneers of the Provincetown scene in a separate room.[21] This honor is significant because it demonstrates a recognition of Lazzell's achievements as an early abstractionist in her lifetime by these younger artists.

Lazzell seems to have developed a particular friendship with Adolph Gottlieb (1903–1974), who came to Provincetown for twelve summers, beginning in 1944. She also became good friends with Gottlieb's mother, Elsie, who bought at least one of her prints.[22] In fact, two months after Lazzell's death, Gottlieb curated the memorial exhibition of her work that was held at the H.C.E. Gallery in Provincetown.[23]

Throughout her life, Lazzell sought out communities of committed avant-garde artists. Provincetown in the summer of 1949 was particularly important because she was recognized by her community of peers. The work she produced in her last few years is a testament to her life-long commitment to abstraction and to a new energy that must have come from her excitement at the critical embrace of American abstraction at mid-century.

The non-objective work that Lazzell produced in the wake of "Forum 49" can be seen as both a summary of her mature aesthetics and as an indication of her absorption of Hofmann's lessons. These works present the culmination of her attitude toward the function of a painting that she had expressed in 1937 (the year she started studying with Hofmann):

> In painting, space is as necessary as objects. So in life—simplicity is all important. A painting is a little universe containing movement, activity, tension, etc of all there is. All this new thought stuff I have been studying for twenty-five or thirty years is now considered the basis of art.[24]

The vertically-oriented oil painting *Abstraction* (1950) (figure 4) is a sure-handed restatement of these previously-explored compositional ideas. In it, Lazzell has employed the hard-edge style of her earlier cubist paintings instead of the brushy, expressionistic technique evident in much of her work of the 1930s and '40s. The perimeter of the image is made up of right-angle planes of pure color. Toward the center, two jagged shapes, one bright red and the other pink, bend sharply and kick out to the upper-right and lower-left corners on a diagonal.

The composition is framed and held to the surface by a right-angled line of gray and black that partially restates the rectangular support of the canvas. Though this is a non-objective image, it seems to have figurative associations that are reminiscent of scenes of Provincetown wharf buildings that Lazzell often pictured in her prints. The peaked top of the pink form calls to mind a

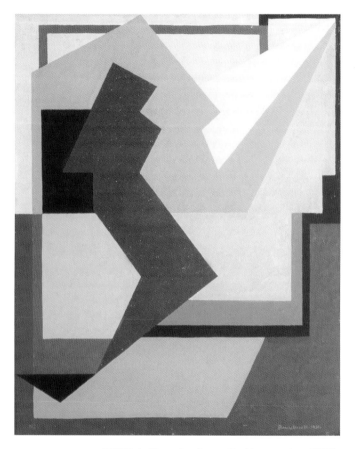

FIGURE 4—**Blanche Lazzell**, *Abstraction* (1950)
oil on canvas, 30 x 24 inches (76.2 x 60 cm)
West Virginia University Art Collection
1995.025.011

house with the black rectangle making a door. There is a sky-blue background at the top, and a meandering path is suggested by the red zig-zag toward the bottom. The whole composition hangs from the black line at the top right edge, a device that Lazzell had employed in earlier paintings.

Movement and spatial play are complex and interesting in *Abstraction*. The dramatic movement diagonally across the canvas is reminiscent of Gleizes's lessons from decades earlier. However, Lazzell has contained that movement within the structure of a right-angled, cubist grid

that gives it a stability that she seemed to prefer. There is a dramatic recession of the pink, yellow, and chartreuse forms into the upper-right corner. It gives the impression of a kind of road sharply receding from the middle ground to the background of the painting. In a manner in keeping with Hofmann's lessons, this recession into a deep space is countered by the surface pull and stability of the right-angled forms.

Another example to consider is the painting *Black and Blue* (1952) (figure 5). This work can be seen as the last installment in Lazzell's series of cubist paintings that were begun decades earlier in Paris. Again, she presents a vertical canvas with overlapping planes grouped toward the

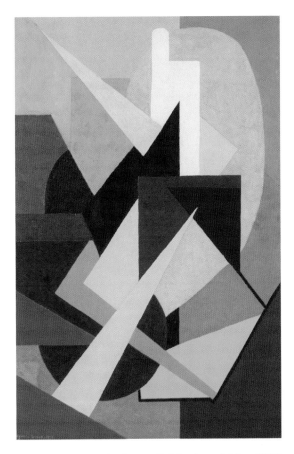

FIGURE 5—**Blanche Lazzell**, *Black and Blue* (1952)
oil on canvas, 28 x 18¼ inches (71.12 x 46.35 cm)
West Virginia and Regional History Collection, 1995.007.003
acquired through Frances Sellers

center. The lack of patterning, rounded pink area at the top right, and notched vertical form at top center make this a very close cousin to several of the earlier paintings.

The movement implied in the composition represents a return to Gleizes's rotated planes. However, Lazzell increases the movement with the two long, shard-like triangles that move in opposite directions and imply a crossing "x" at the center. Farthest back in the work is a grid of rectangular planes. Layered over that are two ovals—pink and black—that bump against each other at different vertical levels. To complete the composition, there is a multi-faceted arrangement of triangular forms of all dimensions and colors that seem to slide along one another's edges. This reliance on dynamic movement achieved through triangles is reminiscent of Hofmann's lessons on spatial tension.

A final example, the print *Planes II* (1952) (figure 6), completes this examination of

Lazzell's late work. Here, the artist returns to her white-line woodblock technique for this non-objective composition. The image is made up of an intricate arrangement of shard-like and rounded forms in planes of pure, intense color. A complicated play of space is at work here. At the same time that a recession is implied from the foreground at the bottom left of the paper to the background at the top right, it is countered by Lazzell's invocation of Hofmann's push/pull among the abstract planes.

The intense color and activation of the planes in all three of these works relate to Hofmann's approach. Specifically, the diagonal movement from corner to corner in each comes from Hofmann's lessons and is unlike the central-focus of Lazzell's cubist compositions done with Gleizes. In her Hofmann class notes, Lazzell had quoted him as saying, "This change of tension makes [the] work more free. Greatest spatial-tensions always coming on the corners."[25] This freedom that comes from Lazzell's deft treatment of the composition is especially evident in *Planes II*. The print is a summary of Lazzell's long-involvement with this cubist composition, reaching back to her first shockingly-abstract prints from the teens, through her paintings of the 1920s, and informed by her drawings made with Hofmann in the thirties.

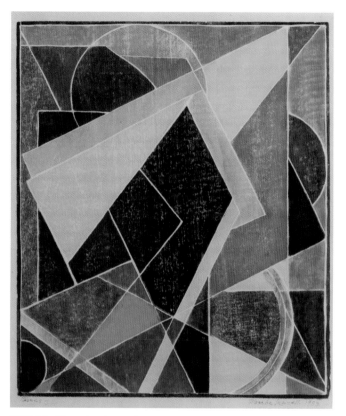

FIGURE 6—**Blanche Lazzell**, *Planes II* (1952) color woodblock print, 14 x 12 inches (35.6 x 30.5 cm) West Virginia University Art Collection, 2004.001 gift of Harvey D. Peyton

These works of the early 1950s show the artist in sure-handed, and even animated, control of her aesthetic goals. Their reliance on cubist geometry, pure color, overlapping, diagonals, and spatial play had been evident for decades in Lazzell's paintings, prints, and decorative work. These interests were given a fresh life after her drawing experience with Hofmann.

By the time Blanche Lazzell took her first drawing class with Hans Hofmann, she was a professional artist well experienced in the vocabulary of modern abstraction. She knew her place in the development of abstract art in America and had rightly been recognized for her role in the development of the Provincetown white-line print in the teens. Hofmann's lessons were actually familiar territory for Lazzell. However, his mentorship and passion for invigorating abstract compositions through movement, spatial tension, and color led Lazzell to a fresh interaction with the visual vocabulary of cubism. Her late oil paintings and prints are some of the best of her career and they were made when she was in her seventies.

Finally, Lazzell certainly understood the importance of her relationship to Hans Hofmann. She summarized her experience with the master teacher in a letter from 1938 to her niece, in which she encouraged the young artist to come study with Hofmann:[26]

> Why don't you come here next summer and study with Hans Hofmann. I studied with him this past summer (I was with him 6 weeks). . . . He does not teach measurements, but thank your stars for what you got from me. (If I do say so myself.) I enjoyed my work with him but of course I did not entirely change my complexion. . . . I entertained his class to tea once. He spoke very highly of my work and studio.[27]

As an independent artist who had made some of the first abstract works of art in America,[28] Lazzell was unlikely to change her complexion for anyone. Hofmann didn't ask her to do so. Rather, through the lessons she learned in his drawing classes, Blanche Lazzell was able to enrich her artistic sensibility and to feel connected, once again, to the revolution of modernist abstraction to which she devoted her entire career.

Kristina Olson is an Assistant Professor of Art History
at West Virginia University

NOTES

[Abbreviations: "AAA, SI" refers to the Archives of American Art, Smithsonian Institution where Lazzell's papers are held. "AMs" indicates an autographed manuscript; "AmsS" means autographed manuscript, signed; "ALS" is an autographed letter, signed.]

[1] See *New York-Provincetown: A 50s Connection* (Provincetown, MA: The Provincetown Art Association and Museum, 1994), 26.

[2] Blanche Lazzell, personal notes, Morgantown, WV, 15 December 1916, AMsS, AAA, SI. This file of notes is a rough draft, which includes the line at the bottom of the last page: "For Hagaus Chapter D.A.R." Lazzell was evidentially preparing for a presentation to the Daughters of the American Revolution about modern art.

[3] The exact number of paintings in this group is unclear. *Painting I, Painting II,* and *Painting III* were all done in Paris in 1924 and exhibited there. The series was resumed when Lazzell was back in the United States with *Painting No.1* of 1925 and continues at least to *Painting XII* of 1928.

[4] Albert Gleizes, *La Peinture et ses lois, ce qui devait sortir du Cubisme* (Paris, 1924). English translation, Painting and Its Laws (London: Francis Boutle, 2001).

[5] Boston Sunday Post, 7 July, 1929; reprinted by John Clarkson, *Blanche Lazzell* (Morgantown, West Virginia: Creative Arts Center Galleries, West Virginia University, 1979), 12.

[6] Cynthia Goodman, "Hans Hofmann as a Teacher," *Arts Magazine* 53 (April 1979): 120-125.

[7] Irving Sandler, "Hans Hofmann: The Pedagogical Master," *Art in America* 61 (May–June 1973): 48-55.

[8] See note one in the Sandler essay and the Estate of Hans Hofmann website at: www.hanshofmann.org.

[9] Harold Rosenberg, "The Teaching of Hans Hofmann," *Arts Magazine* 45 (December 1970–January 1971): 17.

[10] Ibid., 18.

[11] Sandler 1973, 50.

[12] Goodman 1979, 122-123.

[13] Quoted in Goodman 1979, 124.

[14] See, for example, Emily Farnham, *Hofmann: Abstraction as Plastic Expression and Notes Made in Hofmann's Classes* (Provincetown, MA: Shank Painter Co, Inc., 1999); "Hans Hofmann: Artist/Teacher, Teacher/Artist," videorecording narrated by Robert De Niro (Amgott Productions, 2002); and Goodman 1979 above.

[15] Blanche Lazzell, Hofmann class notes, summer 1937, page 3, AMs, AAA,SI.

[16] Lazzell, Hofmann class notes, summer 1937, page 14, AMs, AAA, SI.

[17] See Farnham 1999 above, 22.

[18] Lazzell, Hofmann class notes, summer 1937, page 6, AMs, AAA, SI.

[19] See Tony Vevers, "Abstract Expressionism in Provincetown," in *New York-Provincetown: A 50s Connection* (Provincetown, MA: The Provincetown Art Association and Museum, 1994), 6-7.

[20] Quoted in *The Provincetown Advocate*, 4 August 1949, see Vevers 1994, 7.

[21] See the catalog by Barbara Stern Shapiro for the exhibition, *From Paris to Provincetown: Blanche Lazzell and the Color Woodcut* (Boston: Museum of Fine Arts Publications, 2002), 21.

[22] The print was *Three Boats* made in January 1946 and sold to Elsie Gottlieb in 1954. Blanche Lazzell, "Record Book," AMsS, 125, AAA, SI.

[23] "Notice," 9 August 1956, *The Provincetown Advocate,* AAA, SI. The H.C.E. Gallery was run by Nat Halper who named it after a phrase from James Joyce's *Finnegan's Wake*, "Here Comes Everyone." See Vevers 1994, 7.

[24] Blanche Lazzell, Provincetown, MA to Bessie Ridgway, Morgantown, WV, 18 October 1937, ALS, AAA, SI.

[25] Lazzell, Hofmann class notes, summer 1937, page 16, AMs, AAA, SI.

[26] Grace Martin Frame (1903–1995), later Grace Martin Frame Taylor, became a noted artist in her own right. A distant cousin to Lazzell on her mother's side, Frame was a graduate of the Pennsylvania Academy of Fine Arts and she had taken lessons from Lazzell since 1925.

[27] Blanche Lazzell, Provincetown, MA to Grace Martin Taylor, Charleston, WV, 9 January 1938, ALS, AAA, SI.

[28] This point has recently been made by Roberta Smith in "Wizard of Form Who Found a Career in Color Woodcuts," *The New York Times* (3March 2002): 34, 36, and by Barbara Stern Shapiro in 2002 in terms of Lazzell and Georgia O'Keeffe being the first women artists in America working in a modernist style in the exhibition catalog cited above, 11. See also April Kingsley, "Provincetown Radicals: Women Artists at the Frontiers of Modernism," in *Provincetown Arts* (1988): 68.

PLATES

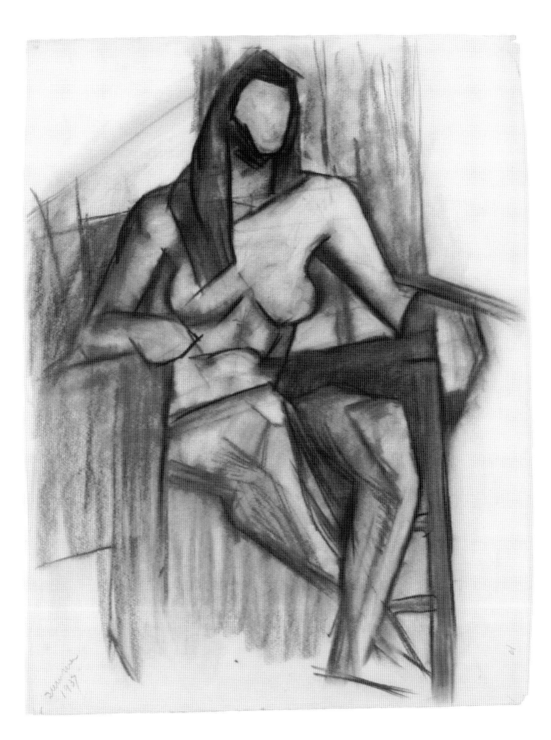

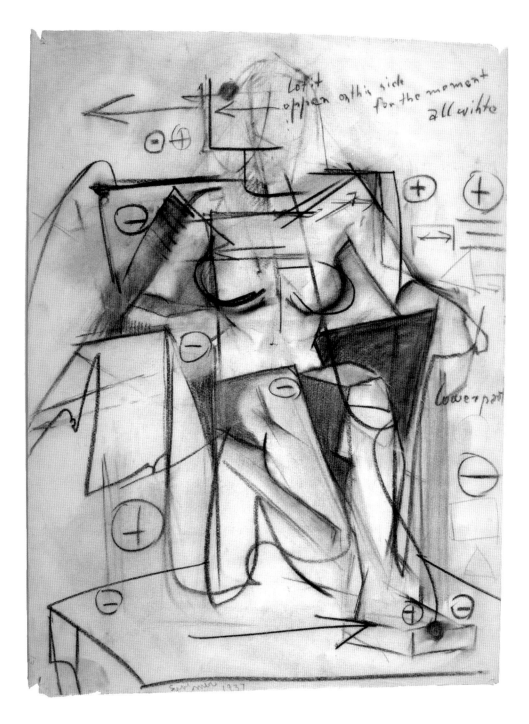

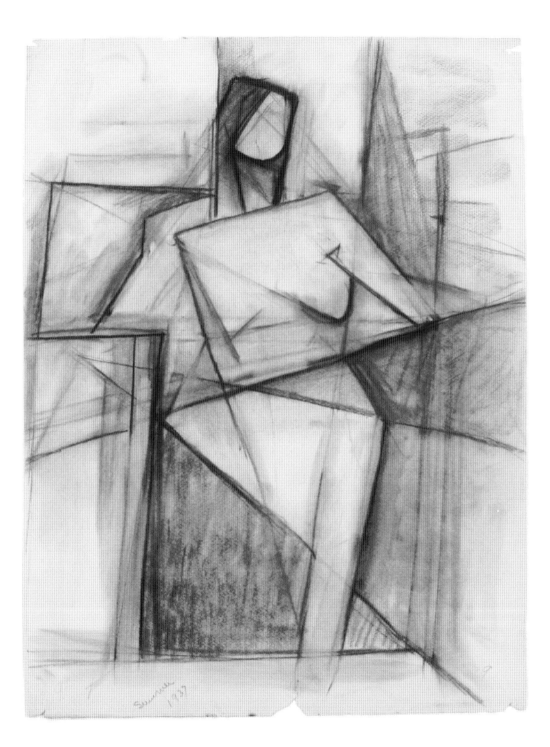

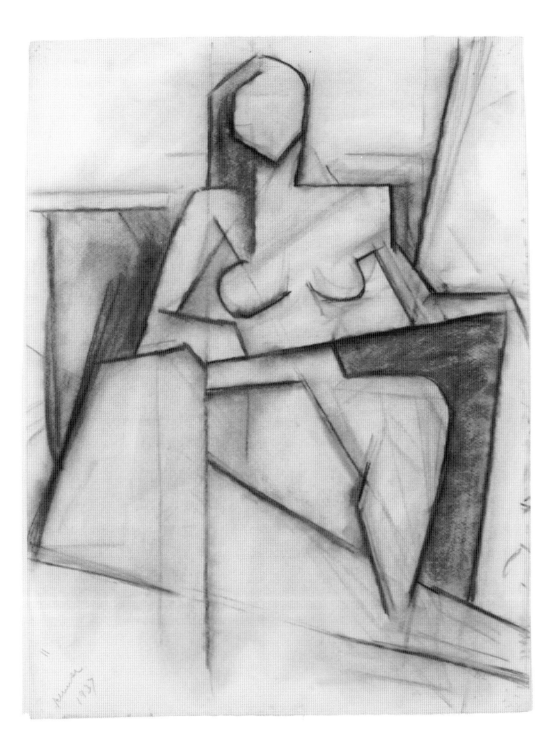

29

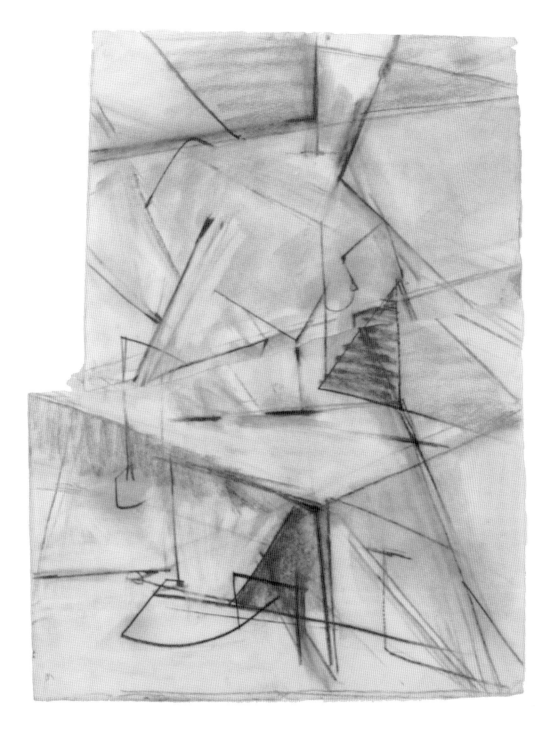

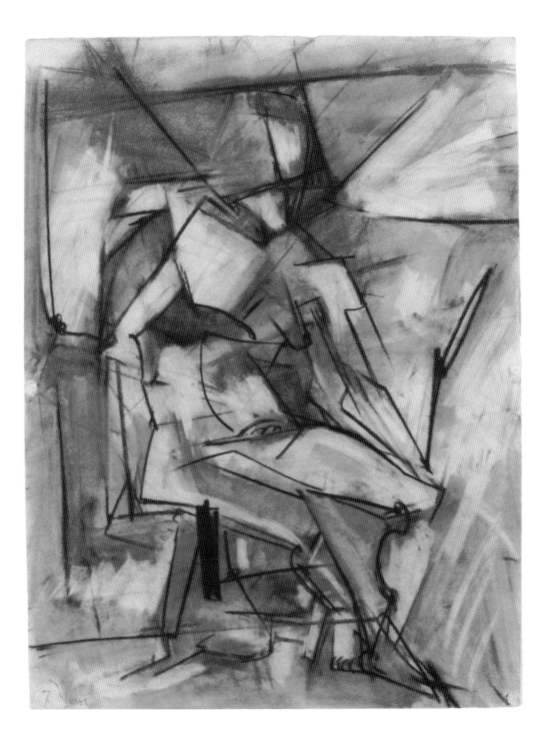

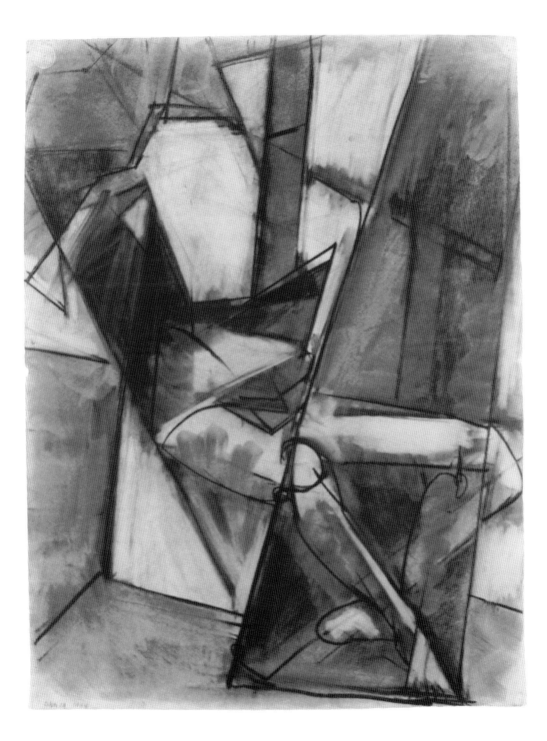

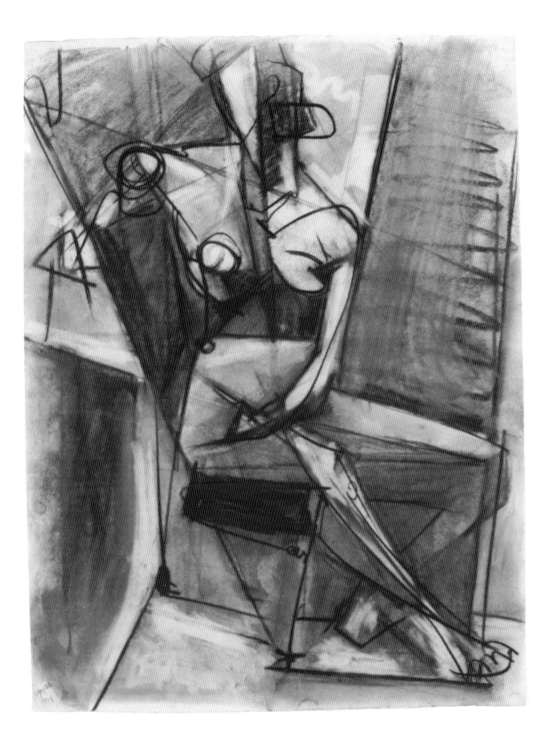

SELECTED CHRONOLOGY

1878
October 10-Blanche Lazzell born near Maidsville, Monongalia County, West Virginia, to Cornelius Carhart Lazzell (1828–1908) and Mary Prudence Pope Lazzell (1841–1891).

1894–1898
Attended West Virginia Conference Seminary (now West Virginia Wesleyan College), graduating in June, 1898.

1899
Attended South Carolina Co-Educational Institute in Edgefield, South Carolina, graduating in June.

1901–1905
Attended West Virginia University, graduating with a degree in fine arts.

1907–1908
Studied with Kenyon Cox and William Merritt Chase at the Art Students League in New York, and at the New York School of Art.

1908–1909
Returned to West Virginia upon the death of her father. Continued to take classes at West Virginia University. Established a studio in Morgantown, and taught art part-time.

1912–1913
Traveled extensively in Europe before settling in Paris. Enrolled in the Académie de la Grande Chaumière, the Académie Delécluse, the Académie Julien, and at the Académie Moderne. Studied with Charles Guérin, G. David Rosen, and others. Attended lectures at The Louvre, visited galleries and the *Salon d'Automne*, and spent six weeks on a sketching tour of Italy.

1915
Summer-Visited Provincetown, Massachusetts. Took classes with Charles Hawthorne at the Cape Cod School of Art.

1916
Summer-Returned to Provincetown. Continued classes with Hawthorne. After seeing the Provincetown Printers' group show, learned white-line woodblock technique from Oliver N. Chaffee. Winter-Studied with Homer Boss and William E. Shumacher in New York.

1917
Summer-Continued work with Shumacher at the Byrdcliffe art colony in Woodstock, New York.

1918
Summer-Moved to Provincetown, and established a studio at 351A Commercial Street. Participated in a show of The Provincetown Printers, the first woodblock print society formed in America, in the Town Hall.

1919
One of eleven artists to participate in the first national show of color woodblock prints by American artists at the Detroit Institute of Arts.

1923
Traveled to Paris to study with Fernand Léger, André Lhote, and Albert Gleizes. Exhibited at the *Salon d'Automne* 1923–1928 and 1930. Showed her color woodblock prints at the American Women's Art Association, Paris.

1925
Returned to Provincetown. Exhibited in *L'Art D'Aujourd'hui*, Exposition International in Paris.

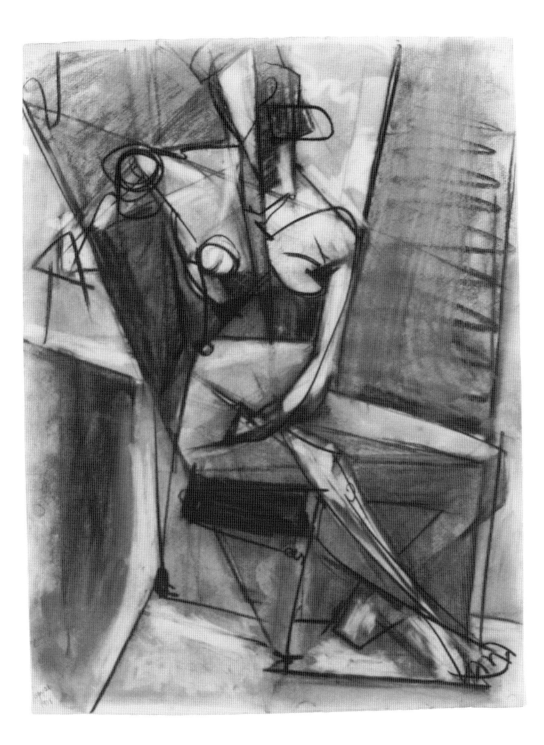

Plate 9–**Hans Hofmann**
Still Life (1943)
watercolor on paper
24 x 19 inches (60 x 48.3cm)
courtesy of Harvey D. Peyton

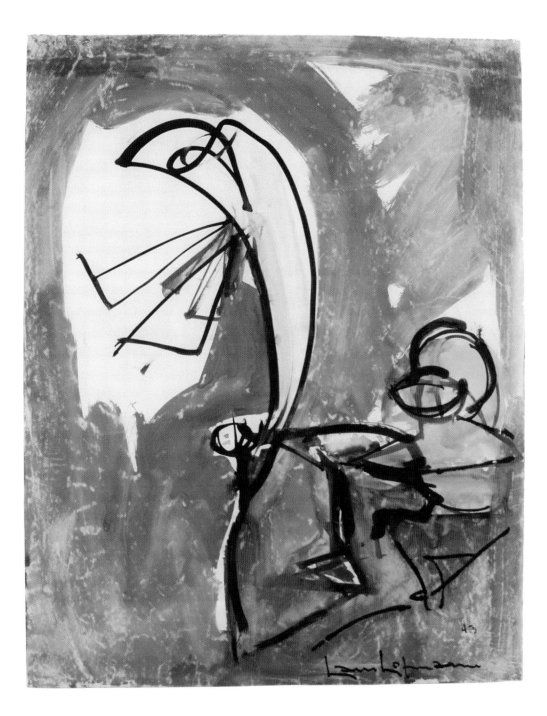

WORKS IN THE EXHIBITION

1. Blanche Lazzell, untitled drawing, marked "summer 1937" (1937), charcoal on paper,
 25 x 19 inches (63.5 x 48.3cm), West Virginia University Art Collection, 1995.002.047

2. Blanche Lazzell, untitled drawing, marked "summer 1937 landscape" (1937), charcoal on paper,
 19 x 25 inches (48.3 x 63.5cm), West Virginia University Art Collection, 1995.002.004

3. Blanche Lazzell, untitled drawing, marked "summer 1937" (1937), charcoal on paper,
 25 x 19 inches (63.5 x 48.3cm), West Virginia University Art Collection, 1995.002.048

4. Blanche Lazzell, untitled drawing, marked "summer 1937" (1937), charcoal on paper,
 19 x 25 inches (48.3 x 63.5cm), West Virginia University Art Collection, 1995.002.031

5. Blanche Lazzell, untitled drawing, marked "summer 1937" (1937), charcoal on paper,
 25 x 19 inches (63.5 x 48.3cm), West Virginia University Art Collection, 1995.002.025

6. Blanche Lazzell, untitled drawing, marked "summer 1937" (1937), charcoal on paper,
 25 x 19 inches (63.5 x 48.3 cm), West Virginia University Art Collection, 1995.002.038

7. Blanche Lazzell, untitled drawing, marked "summer 1937" (1937), charcoal on paper,
 25 x 19 inches (63.5 x 48.3cm), West Virginia University Art Collection, 1995.002.027

8. Blanche Lazzell, untitled drawing, marked "summer 1937" (1937), charcoal on paper,
 25 x 19 inches (63.5 x 48.3 cm), West Virginia University Art Collection, 1995.002.030

9. Blanche Lazzell, untitled drawing, marked "summer 1937" (1937), charcoal on paper,
 25 x 19 inches (63.5 x 48.3cm), West Virginia University Art Collection, 1995.002.012

10. Blanche Lazzell, untitled drawing, marked "summer 1937" (1937), charcoal on paper,
 25 x 19 inches (63.5 x 48.3cm), West Virginia University Art Collection, 1995.002.013

11. Blanche Lazzell, untitled drawing, marked "summer 1937" (1937), charcoal on paper,
 19 x 25 inches (48.3 x 63.5cm), West Virginia University Art Collection, 1995.002.010

12. Blanche Lazzell, untitled drawing, marked "summer 1937" (1937), charcoal on paper,
 25 x 19 inches (63.5 x 48.3cm), West Virginia University Art Collection, 1995.002.035

13. Blanche Lazzell, untitled drawing, marked "1937" (1937), charcoal on paper,
 25 x 19 inches (63.5 x 48.3 cm), West Virginia University Art Collection, 1995.002.046

14. Blanche Lazzell, untitled drawing, marked "Sept. 1937" (1937), charcoal on paper,
 19 x 25 inches (48.3 x 63.5cm), West Virginia University Art Collection, 1995.002.049

15. Blanche Lazzell, untitled drawing, marked "Sept. 1937" (1937), charcoal on paper,
 19 x 25 inches (48.3 x 63.5cm), West Virginia University Art Collection, 1995.002.029

16. Blanche Lazzell, untitled drawing, marked "spring 1938 N.Y.C." (1938), charcoal on paper, 25 x 19 inches (63.5 x 48.3 cm), West Virginia University Art Collection, 1995.002.054

17. Blanche Lazzell, untitled drawing, marked "spring 1938 NYC" (1938), charcoal on paper, 25 x 19 inches (63.5 x 48.3cm), West Virginia University Art Collection, 1995.002.023

18. Blanche Lazzell, untitled drawing, marked "Apr. 14 1938" (1938), charcoal on paper, 25 x 19 inches (63.5 x 48.3cm), West Virginia University Art Collection, 1995.002.050

19. Blanche Lazzell, untitled drawing, marked "April 19, 1938" (1938), charcoal on paper, 25 x 19 inches (63.5 x 48.3cm), West Virginia University Art Collection, 1995.002.017

20. Blanche Lazzell, untitled drawing, marked "April 26, 1938" (1938), charcoal on paper, 25 x 19 inches (63.5 x 48.3cm), West Virginia University Art Collection, 1995.002.020

21. Blanche Lazzell, untitled drawing, marked "April 1938 NYC" (1938), charcoal on paper, 25 x 19 inches (63.5 x 48.3 cm), West Virginia University Art Collection, 1995.002.037

22. Blanche Lazzell, untitled drawing, marked "summer 1938" (1938), charcoal on paper, 19 x 25 inches (48.3 x 63.5cm), West Virginia University Art Collection, 1995.002.033

23. Blanche Lazzell, untitled drawing, marked "summer 1938" (1938), charcoal on paper, 19 x 25 inches (48.3 x 63.5cm), West Virginia University Art Collection, 1995.002.008

24. Blanche Lazzell, untitled drawing, marked "summer 1938" (1938), charcoal on paper, 25 x 19 inches (63.5 x 48.3 cm), West Virginia University Art Collection, 1995.002.053

25. Blanche Lazzell, untitled drawing, marked "summer 1938" (1938), charcoal on paper, 19 x 25 inches (48.3 x 63.5cm), West Virginia University Art Collection, 1995.002.040

26. Blanche Lazzell, untitled drawing, marked "summer 1938" (1938), charcoal on paper, 19 x 25 inches (48.3 x 63.5cm), West Virginia University Art Collection, 1995.002.055

27. Blanche Lazzell, untitled drawing, marked "summer 1938" (1938), charcoal on paper, 25 x 19 inches (63.5 x 48.3cm), West Virginia University Art Collection, 1995.002.009

28. Blanche Lazzell, untitled drawing, marked "B. Lazzell 1938" (1938), charcoal on paper, 25 x 19 inches (63.5 x 48.3 cm), West Virginia University Art Collection, 1995.002.005

29. Blanche Lazzell, untitled drawing, marked "summer 1938" (1938), charcoal on paper, 19 x 25 inches (48.3 x 63.5cm), West Virginia University Art Collection, 1995.002.016

30. Hans Hofmann, *Still Life* (1943), watercolor on paper, 24 x 19 inches (60 x 48.3cm), courtesy of Harvey D. Peyton

SELECTED CHRONOLOGY

1878
October 10-Blanche Lazzell born near Maidsville, Monongalia County, West Virginia, to Cornelius Carhart Lazzell (1828–1908) and Mary Prudence Pope Lazzell (1841–1891).

1894–1898
Attended West Virginia Conference Seminary (now West Virginia Wesleyan College), graduating in June, 1898.

1899
Attended South Carolina Co-Educational Institute in Edgefield, South Carolina, graduating in June.

1901–1905
Attended West Virginia University, graduating with a degree in fine arts.

1907–1908
Studied with Kenyon Cox and William Merritt Chase at the Art Students League in New York, and at the New York School of Art.

1908–1909
Returned to West Virginia upon the death of her father. Continued to take classes at West Virginia University. Established a studio in Morgantown, and taught art part-time.

1912–1913
Traveled extensively in Europe before settling in Paris. Enrolled in the Académie de la Grande Chaumière, the Académie Delécluse, the Académie Julien, and at the Académie Moderne. Studied with Charles Guérin, G. David Rosen, and others. Attended lectures at The Louvre, visited galleries and the *Salon d'Automne,* and spent six weeks on a sketching tour of Italy.

1915
Summer-Visited Provincetown, Massachusetts. Took classes with Charles Hawthorne at the Cape Cod School of Art.

1916
Summer-Returned to Provincetown. Continued classes with Hawthorne. After seeing the Provincetown Printers' group show, learned white-line woodblock technique from Oliver N. Chaffee. Winter-Studied with Homer Boss and William E. Shumacher in New York.

1917
Summer-Continued work with Shumacher at the Byrdcliffe art colony in Woodstock, New York.

1918
Summer-Moved to Provincetown, and established a studio at 351A Commercial Street. Participated in a show of The Provincetown Printers, the first woodblock print society formed in America, in the Town Hall.

1919
One of eleven artists to participate in the first national show of color woodblock prints by American artists at the Detroit Institute of Arts.

1923
Traveled to Paris to study with Fernand Léger, André Lhote, and Albert Gleizes. Exhibited at the *Salon d'Automne* 1923–1928 and 1930. Showed her color woodblock prints at the American Women's Art Association, Paris.

1925
Returned to Provincetown. Exhibited in *L'Art D'Aujourd'hui,* Exposition International in Paris.

1925–1926
Invited to serve on the board of the Société Anomyme. Served as a juror on the *Modern Exhibition* selection committee for the Provincetown Art Association Annual Show.

1926
Exhibited with the New York Society of Women Artists.

1927
Exhibited at *The First Modernistic Exhibition*, Provincetown Art Association.

1929
Included in the *First International Exhibition of Lithography and Wood Engraving* at the Art Institute of Chicago.

1934
Received commission from the Public Works of Art Project for the Monongalia County, West Virginia, courthouse mural known as *Justice Over Monongalia County.* Received commission from the Public Works of Art Project for a series of color woodblock prints of historical scenes of Morgantown. Included in the PWPA Exhibition at the Corcoran Gallery, Washington, D.C.

1936
Exhibited at the Museum of Modern Art, New York.

1936–1939
Created works for the Works Progress Administration of Massachusetts.

1937–1938
Participated in drawing classes with Hans Hofmann, Provincetown and New York.

1939
Served as juror for the Massachusetts section of the New York World's Fair art exhibition. Exhibited at the 1939 World's Fair in a show organized by the Works Progress Administration.

1940
Exhibited at the Smithsonian Institution, Washington, D.C.

1941
Included in exhibitions at The Philadelphia Print Club, The New York Society of Women Artists, and the Whitney Museum of American Art.

1943
Exhibited in New York Society of Women Artists and the Ravenscroft Gallery, New York.

1946
Exhibited in the Carnegie Art Institute, Pittsburgh, Pennsylvania.

1949
Exhibited at "Forum 49," Provincetown along with Ambrose Webster, Oliver Chaffee, and Agnes Weinrich.

1956
June 1 - Died, age 77, in Barnstable Hospital, Barnstable, Massachusetts. *Provincetown Art Association Memorial Exhibition,* work selected by Adolph Gottlieb, HCE Gallery, Provincetown.

1979–1980
Blanche Lazzell, a retrospective exhibition, curated by John Clarkson, at the Creative Arts Center at West Virginia University, Morgantown, West Virginia.

1982
Blanche Lazzell, Pioneer American Cubist, Works from 1920–1950, Martin Diamond Fine Arts, New York.

1984
Work exhibited in *Feminine Gaze: Women Depicted by Women 1900–1930* at the Whitney Museum of American Art in Fairfield County, Stanford, Connecticut.
Emil Bisttram and Blanche Lazzell, Martin Diamond Fine Arts, New York.

1985
Blanche Lazzell: Woodblock Prints in Color, Martin Diamond Fine Arts, New York.

1990
Work exhibited in *A Spectrum of Innovation: Color in American Printmaking, 1890–1960,* curated by David Acton, at the Worcester Art Museum, Worcester, Massachusetts; Amon Carter Museum, Fort Worth, Texas; and the NelsonAtkins Museum of Art, Kansas City, Missouri.

1991
Blanche Lazzell: A Modernist Revisited, Archives of American Art, New Regional Center, New York.

1997
Work exhibited in *Singular Impressions: The Monotyype in America,* National Museum of American Art, Smithsonian Institution, Washington, D.C.

1999
Work exhibited in *Drawn Across the Century: Highlights from the Dillard Collection of Art on Paper,* Weatherspoon Art Gallery, University of North Carolina at Greensboro, Greensboro, North Carolina.

2000
Blanche Lazzell: American Modernist, Michael Rosenfeld Gallery, New York, NY.
The Art of the Provincetown Print, Demuth Foundation, Lancaster, Pennsylvania.
Hard Pressed: Six Hundred Years of Prints and Processes, International Print Center, AXA Gallery, New York.

2002
From Paris to Provincetown: Blanche Lazzell and the Color Woodcut, curated by Barbara Stern Schapiro, at the Boston Museum of Fine Arts; Cleveland Museum of Art; and Elvehjem Museum of Art, Madison, Wisconsin.

2003
Against the Grain: Woodcuts from the Collection, Cleveland Museum of Art.
A TransAtlantic AvantGarde: American Artists in Paris, 1918–1939, organized by Sophie Lévy for the Musée d'Art Américain Giverny, France.

[This chronology is based primarily on original research by Susan M. Doll; Blanche Lazzell's papers at the Provincetown Art Association and Museum; Lazzell's guest book, record book, travel diaries, and letters, some of which are in the West Virginia and Regional History Collection at West Virginia University or in the Archives of American Art, Smithsonian Institution; John Clarkson, *Blanche Lazzell* (Morgantown, 1979); Michael Rosenfeld Gallery, *Blanche Lazzell, American Modernist* (New York, 2000), and Barbara Stern Shapiro, *From Paris to Provincetown: Blanche Lazzell and the Color Woodcut* (Boston, 2002).]